A FEW
COLLECTORS

A
FEW
COLLECTORS

PIERRE LE~TAN

Translated from the French by Michael Z. Wise

NEW VESSEL PRESS

New Vessel Press

www.newvesselpress.com

First published in French as *Quelques collectionneurs*

Copyright © Flammarion, Paris, 2013

Translation copyright © New Vessel Press, 2022

Library of Congress Cataloging-in-Publication Data
Le-Tan, Pierre
[Quelques collectionneurs, English]
A Few Collectors/Pierre Le-Tan; translation by Michael Z. Wise.
p. cm.
ISBN 978-1-954404-04-5

Library of Congress Control Number 2021940775
France – Nonfiction

For Toboré,
Patient companion of a collector

Contents

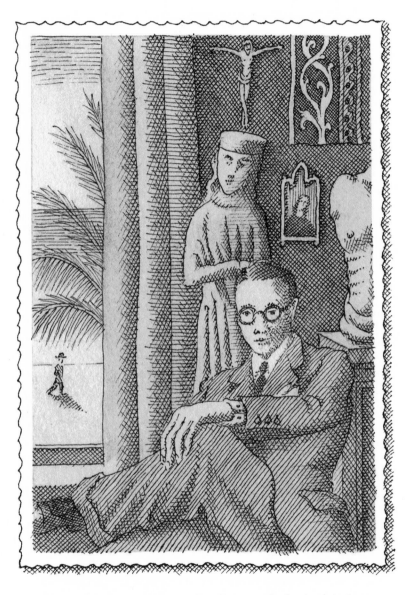

My father in his apartment in Nice, Promenade des Anglais, in 1943.

Introduction

"The next day, if it's Sunday, I will have walked in the countryside, alone with my young friend the painter Le-Pho; together we will have sought out the landscape's beautiful aspects, the serenity of an old pagoda courtyard, I will have discussed the merits of my friend's latest painting. Then we will have spent a long while conversing, seated in front of a tiny cup of tea in that tranquil room where, among ancient Chinese vases, my friend's ancestors, great mandarins and patrons of the arts, received painters and poets; the day will have gradually faded away, silky and ashen, among the dwarf trees, like those in a Florentine monastery—silence, contemplation—the wind in the leaves—a servant sweeping the court. An Annamese day."

This excerpt from a letter, addressed to the novelist and future Nobel laureate Roger Martin du Gard in 1928 by the poet Jean Tardieu during a sojourn in Hanoi, continues to

give me pause for reverie. Those ancient Chinese vases, vanished long ago, are, in my mind, the origin of my father's taste for collecting, a taste that he passed in turn on to me.

Having by then been in France for three or four years, my father, a young Vietnamese painter, settled in Nice during the war, on the Promenade des Anglais. A few small photographs show an interior that reminds me of that of Anatole France: old textiles, medieval religious sculptures, *Haute Époque* furniture, and even a chamfron, a kind of metal mask worn by warhorses during the Renaissance.

I've always wondered how this young man, coming from such a different, faraway land, managed to assimilate into a new culture so rapidly. It's true that his teacher, the painter Victor Tardieu, father of Jean, taught him the basics. He had also taken a long journey in 1931, from the Netherlands to Italy, exploring all the museums.

Later in Paris I grew up amid this furniture and these objects, mixed also with Chinese ceramics. From my childhood on, my father took me to both museums and antique shops. How could I help, then, but become an insatiable collector? Even if, in fact, this was not the case for my brother, who was more interested in technology than the arts.

Since those long-ago years, I haven't ceased to look for, search out, desire, and acquire objects and artworks. No, I'm never satisfied, even if at times this uninterrupted accumulation does provoke a kind of nausea.

The following chapters conjure up a few collections and their owners. With this small selection I by no means seek to describe all types of collectors. These are just a few characters who have managed to interest, intrigue, or amuse me.

A FEW
COLLECTORS

The collection of the Princess of Brioni.

The Princess of Brioni

My parents sometimes took me along to musical soirées hosted by an old Austrian couple who lived in Paris: the Schenker-Angerers. My father must have met them before the war. The husband was always in the shadow of his wife, the driving force at these little concerts. Descended from the painter Leopold Kupelwieser, a close friend of Schubert, she was the princess of Brioni, a tiny archipelago off the coast of Yugoslavia.

They lived in a vast apartment on a cul-de-sac that bore the pretty name of Villaret-de-Joyeuse. The candlelight and thick curtains gave it a sumptuous air. Great performers came to play the old Steinway. That's how I came to hear Aldo Ciccolini perform the Gnossiennes of Erik Satie. The concert was followed by drinks around an imposing silver candelabrum. Guests would savor delicious Viennese pastries prepared by

the princess. That was the moment the little boy I was then most eagerly awaited.

One time my father forgot his hat there and sent me to retrieve it. I took the Metro and descended into the Argentine Station, then called Obligado, as I recall. The princess greeted me, curiously attired in a long gown like those she wore to the soirées. She seemed delighted to see me.

The apartment was rather dark, but in the light of day I couldn't help but notice the shabbiness of the rooms. The heavy curtains were singed by the sun and hung in tatters. One might have thought the place was abandoned. But what struck me most were the large spots of discoloration covering the walls. Marie-Louise—that was her first name—noticed my surprise and without the least embarrassment told me that she and her husband had been gradually disencumbering themselves of the paintings that they owned, having virtually no other source of income.

We spent a long time examining each rectangle. She enumerated all the pictures that had once covered them: *The Pilgrims at Emmaus* by Theodoor van Thulden (1606–1669), *Achilles Among the Daughters of Lycomedes* by Peter Paul Rubens (1577–1640), *Allegory of Fortune* by Giovanni Francesco Barbieri, called Guercino (1591–1666), *Saint Ignatius of Antioch* by Fra Paolino da Pistoia (1488–1547) . . . To enumerate them all would take too long. It was, in any case, a magnificent collection, one portion of which had been inherited, and the rest

The only image kept by Marie-Louise Shenker-Angerer:
an etching after Tiepolo.

acquired over the years. Aware of my taste for the arts, their former owner didn't hesitate to list the now missing works in a way that was more moving than if I'd seen the pictures themselves.

One lone work remained, beside the piano: a small etching, after a drawing by Giovanni Battista Tiepolo, done by the Abbot of Saint-Non (1727–1791). It depicted the commedia dell'arte character Pulcinella drunk and asleep, his hat beside him, seen from the same perspective as Mantegna's *Lamentation of Christ*, preserved in the Pinacoteca di Brera in Milan.

Visiting this vanished collection was a lesson for me. Things that are coveted so, then acquired, always end up escaping our grasp again.

The princess embraced me at the front door. I noticed she was wearing false eyelashes that she'd put on backwards. They covered her eyes with a charming latticework.

Peter Hinwood

Does anyone remember *The Rocky Horror Picture Show*, the English musical comedy that was later adapted for film? The cast included a tall athletic blond with very pale eyes. That was Peter Hinwood.

Years later I met him in the shop owned by his friend Christopher Gibbs, without a doubt one of the best antique dealers of the past forty years. His charm and very particular, impeccable taste attracted the most prestigious clients, from Mick Jagger to John Paul Getty.

But it's Peter that I'd like to talk about here. He was a young fellow of singular beauty who dressed as only certain Englishmen know how. Some might have thought that the bold colors of his striped shirts and gold teeth made him appear ungentlemanly. He managed to turn it all into a magnificently alluring look that was tempered by his excellent upbringing and an affecting shyness.

I often stopped by the shop and talked with him about one of my very eccentric English cousins who would spend hours there and end up buying bizarre objects like a fragment of ancient Japanese armor adorned with a gilt rabbit.

I also saw Peter when I went to Tangier. He stayed in a small house on Christopher's grand property on the Vieille Montagne that dominated the Strait of Gibraltar. Everything in its two modestly proportioned rooms was ravishing and amusing, and sparked curiosity.

While in London, I had the privilege of being invited to his home. I say privilege because few people had the opportunity to infiltrate this great loner's lair. I thought that his apartment was one of the most beautiful and one of the most original that I have ever seen. I always cite it is as an example when I am told about great collections that are of almost no interest to me, such as that of Yves Saint Laurent and Pierre Bergé. Just three rooms of wonderful proportions in a house near Marble Arch. The walls were painted in acid colors, very English, like his shirts. They matched the numerous Islamic tiles, most of them purchased for practically nothing at a time when nobody so much as looked at them, even though they attracted the interest of the most important collectors of the early twentieth century, such as Louis Gonse or Raymond Koechlin. These were arranged amid other marvels like a Chinese porcelain vase decorated with fish or a monumental folding screen whose provenance, whether Chinese or Japanese, was uncertain. The

Peter Hinwood's home in London.

Peter Hinwood in The Rocky Horror Picture Show in 1975.

play of colors and materials (ceramic, textiles, marble) created a harmony I never again found anywhere else. There was, in addition, a very special touch that can be defined only by an English adjective for which I fail to find a French equivalent: *quirky*—a mélange of fantasy, eccentricity, and humor.

I believe that Peter lived only for objects. Researching, discovering, acquiring, and installing them in his lair.

Some people paint, write, or make music. Peter, who I believe came from a family of artists, didn't do anything like that. But this great man with a gentle aspect who never expressed a negative feeling created, in just three rooms, something indefinable that could be considered a work of art.

Edouard M.

It was at the Monte-Carlo Beach in Monaco, an absurdly luxurious hotel overlooking the sea, where you can see the famous Rock of Monaco. A place where you encountered nothing but rich Russians and their courtesans. I don't recall why I was there.

Edouard M. was there, leaning against a balustrade that resembled the railing on a ship. Previously in Paris, I had met this unshaven Monégasque whose arched eyebrows gave him a mournful air, but I had forgotten him. He ran a contemporary art gallery. As we chatted, I realized that this specialist in conceptual art—something that had interested me when I was young but means nothing to me today—had an insatiable curiosity. He talked to me about old photographs, carved flint artifacts, and even Chinese ceramics. Around us, men in black T-shirts covered with jewelry held scantily clad young creatures in their bulging arms. We laughed a lot.

I saw him again in Paris. By an odd coincidence he resided in the same apartment where one of my oldest friends, Franck M., used to live. A rather modest place, but full of charm, with views of the pagoda, that marvelous folly constructed at the turn of the century, the roof of which had been covered in plastic, pending an unlikely restoration. You could also see the building where Yves Saint Laurent lived. Franck told me he could see him from his window; he was always looking for the piece of paper with the entry code to his front door. The Rolling Stone Mick Jagger, that aging rumpled adolescent, also stayed in that building when he visited Paris.

There was nothing impressive about Edouard's place. There was hardly any furniture; it was a sort of billet. But one still got the sense of a real personality. First, on the wall over his desk, a small white bulletin board where his drawings were tacked up; they looked a bit like Antonin Artaud's, enhanced by fluorescent colors. All kinds of other papers as well, invitations, notes. Later, I found sketches that I myself had scribbled on restaurant linens.

A huge model of a warship took up one entire room. He had bought it at a sale in the port of Cherbourg where the contents of a local museum were being liquidated. But it was primarily in his bedroom that he displayed his latest finds, some of them under glass bells: a vertebra painted to look like a human figure, some flints, a dildo that once belonged to the poet and Nazi collaborator Robert Brasillach, a nude

A charming photograph, a flint, a medieval key, and an Inuit statuette.

An image of Edouard scribbled on a restaurant tablecloth.

photograph of film actress Michèle Morgan proudly displaying her crotch, Mikhail Bakunin's passport and keys, along with many other keys dating back to the Middle Ages. None of these objects left you indifferent.

We spent many evenings, even entire nights, poring over auction house sales on his computer, a tool that I neither possessed nor knew how to use. He took notes in his many notebooks.

I knew that he stored things in Monaco, in his parents' apartment in the Palais Brummell (this is how certain residential buildings on the Côte d'Azur, especially in Nice, are named). He also had a storage depot in Cachan in the suburbs

of Paris, or somewhere like that. A mysterious sort, this Edouard, who had British citizenship for no reason I knew, and whose mastery of the English language was rather approximate. I never knew what really belonged to him. Regardless, I always sensed an unquenchable collector's thirst in that man with whom—yet another coincidence—I shared my swimming instructor, Émile Schoebel.

Monsieur Wu had worn a black tie since the abdication
of Emperor Pu Yi in 1945.

Monsieur Wu

I was a little boy. My parents had taken me with them to visit some friends who were renting a nondescript house surrounded by a beautiful garden on the outskirts of Paris for the weekends. It actually belonged to Monsieur Wu, an elderly Chinese man who lived in a small pavilion at the rear of the garden. When we arrived, I noticed Chinese characters above the entry portal.

I couldn't have been more than ten years old. I was bored. Knowing my eccentric tastes—I was more interested in the arts of Asia than toys—my parents' friends informed me that the elderly Chinese gentleman had one of the most beautiful porcelain collections imaginable and that he would be happy to show me catalogues of this collection, the only traces of it that remained, since he had sold off the entire thing.

They took me to see him. I was exceedingly shy, but the old gentleman welcomed me with a complete lack of pretense,

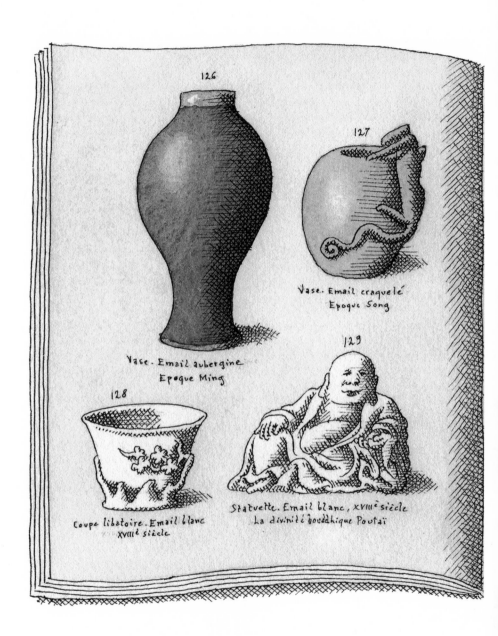

126

127

Vase. Email craquelé
Epoque Song

Vase. Email aubergine
Epoque Ming

128

129

Coupe libatoire. Email blanc
XVIIIᵉ siècle

Statuette. Email blanc, XVIIIᵉ siècle
La divinité bouddhique Poutaï

Two pages from the catalogues of Monsieur Wu's

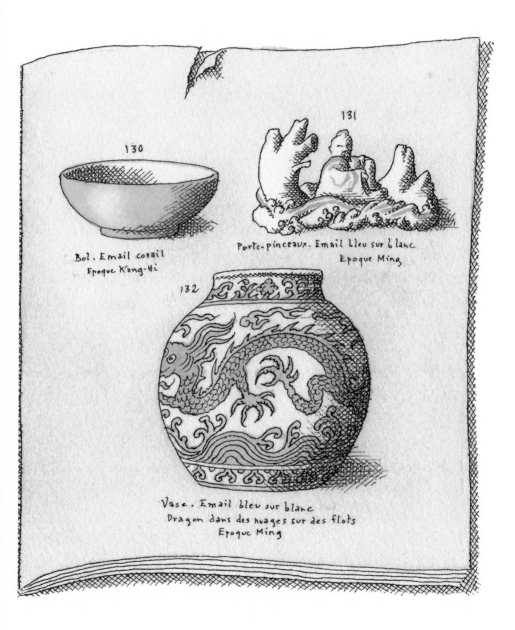

130

Bol. Email corail
Epoque K'ang-Hi

131

Porte-pinceaux. Email bleu sur blanc
Epoque Ming

132

Vase. Email bleu sur blanc
Dragon dans des nuages sur des flots
Epoque Ming

former collection of Chinese ceramics.

putting me at ease. His little house, which must have been meant for the caretaker of the property, was stripped nearly bare. There were just a few pieces of Chinese furniture. I realize today that they must have been incredibly beautiful. I sat in an austere armchair fashioned of dark wood, and he brought me several albums bound in the Chinese style. Every one of the objects in his collection had been designed by an Asian artist. I carefully inspected each page. Incapable of asking questions, I watched hundreds of objects parade before my eyes, while he observed me with a smile.

We eventually left this unreal place. The car belonging to my parents' friends—a sleek German-made Borgward Isabella cabriolet—was parked in an alleyway in the garden.

On the way back, I thought about those porcelains, similar to the ones at the Musée Guimet of Asian Art, which I would visit with my nanny. The vast collection assembled by Ernest Grandidier...

Recently, when I saw reproductions from the album of Emperor Qianlong depicting objects he once owned, I remembered those volumes belonging to Monsieur Wu, and the good fortune that allowed me to see them.

Éric Marc-Albouin

I have the impression that his name alone summons up an idea of his character: Éric Marc-Albouin. A big type, lean, flattop haircut, large tortoiseshell glasses. He invariably wore an impeccable gray flannel suit (tailored by Caraceni, Huntsman?) and a dark knit tie. His age was a mystery.

I was referred to him by a friend. He helped me deal with a financial matter I couldn't at all understand. That's how I discovered his house, one of those very bourgeois, small buildings in a street in the 16th arrondissement that was as depressing as it was well-off.

Everything in it dazzled me. A very knowledgeable mix of the finest Art Nouveau and what constituted the French avant-garde in the sixties. Furniture by Hector Guimard, some older objects chosen with utmost care, and works, among others, by Martial Raysse, Pierre Bettencourt, Daniel Spoerri, and Robert Malaval.

Éric Marc-Albouin in front of a work by Robert Malaval.

A work by the latter was particularly troubling to me. It dated from his so-called "white food" period, a theme he had invented, creating an entire universe of unwholesome beauty. I sometimes crossed paths with this affable artist in the course of drunken evenings, usually at a dark bar near the Théâtre de l'Odéon that stayed open very late. He committed suicide not long afterward in the shop he used as his studio on rue du Pont Louis-Philippe. Summertime in Paris often proves fatal for sensitive types.

Éric spoke little, but he exuded genuine kindness, and when he started talking about a work or even a piece of furniture, you could feel the ardor of a true collector. He was a bachelor and no one knew anything about his private life. Perhaps he didn't have one. In this cosseted atmosphere, each object had such a presence that no doubt he had no need for anything else, or, surely, anyone. Once evening fell he probably sat on the plush tufted sofa and scrutinized each work, illuminated to perfection, a glass in hand. He must have savored this ephemeral satisfaction—absurd, perhaps, but so immense—of being surrounded by objects that one has chosen with love.

Umberto examining an Iznik tile.

Umberto Pasti

Noëlle M. was eager to introduce me to an Italian friend she had met in Tangier. His name was Umberto Pasti. I'd already been told he was passionate about Philippe Jullian, a writer and illustrator I admired, an amusing character, learned and delightfully wicked, who ended his days in 1977. Umberto had also written a highly laudatory article about one of my books a few years before in an Italian newspaper.

We met in an old *salon de thé*, beneath the arcades of the rue de Rivoli. He resembled one of those Roman busts from the beginning of the classical period.

It was only later that we became friends, and he was the person I chose to be my youngest son's godfather. We saw each other often over the course of a summer in Tangier more than twenty years ago. We had many things in common, particularly an immoderate taste for collecting.

At that time his Moroccan villa was not yet the cave of Ali

Baba that it would become. The former residence of Sanche de Gramont—better known by the name of Ted Morgan—the biographer of Somerset Maugham, it was a small house filled with charming bric-a-brac picked up at the Casa Barata, the local flea market.

In the Milanese apartment he shared with Stephan Janson, I discovered Umberto's collections, accumulated since adolescence. Feathers from South America, archaeological fragments, works from a period that interested us both: drawings by Filippo de Pisis, Philippe Jullian, Pavel Tchelitchew of course, some paintings by Christian Bérard and the Berman brothers, Eugène and Leonid... As was the case in my own house, books were piled everywhere.

His collection of Islamic tiles was just getting started. It established itself in the years that followed, in Milan as well as in Tangier. Timurid, Safavid, Mamluk, Iznik, Damascus, the tiles were arrayed on tables, in vitrines, hung, and even affixed to the walls at Tebarek Allah, his Tangier residence that became a palace. Previously I had believed that these pieces of siliceous ceramics belonged on the walls of Turkish or Persian mosques; in isolation, they seemed meaningless to me. I've since changed my mind.

I won't talk here about the collections of bulbs and plants that invaded the gardens of my Italian friend. This is a subject I know little about that could make up an entire book of its own.

Umberto Pasti

I see Umberto two or three times a year, mostly in Paris, because I have the flaw of finding travel to be more and more of an annoyance. We rummage relentlessly around antique shops together, with the same excitement as always, as if it were the first time. We generally conclude our circumnavigations in a timeless bookstore near the Jardins du Luxembourg: the Librairie Orientale H. Samuelian, run by two old Armenians, a brother and a sister. We have a shared condition: like me, they don't own a computer and keep their files on yellowed paper held together by rubber bands. Umberto and I wonder what will become of us when this magnificent place of knowledge disappears.

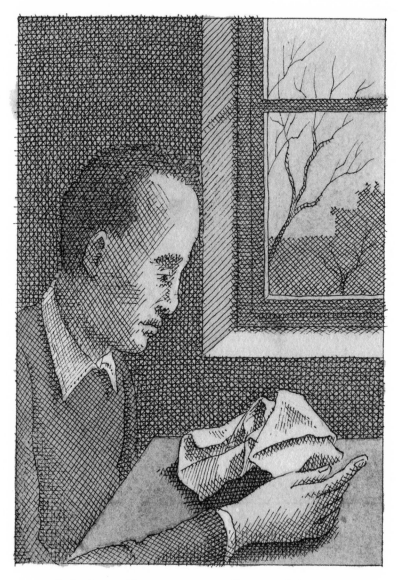

Pedro Duytveld examining one of his crumpled papers.

Pedro Duytveld

P edro Duytveld was sitting across from me on a train to
Zurich. We hadn't yet spoken. I was absorbed in reading
a book I remember well, the biography of Virginia Woolf by
her nephew Quentin Bell, which had just been published. That
allows me to correctly date the trip: 1972. From the railway car
window, we caught sight of the impressive factory where they
make that liqueur that tastes like varnish, Fernet-Branca. My
neighbor couldn't help but comment on this old-fashioned
brick building that had struck me as well. That's how we got
to know each other.

I was unsure where Pedro—thin, very dark, a man with an
intense expression—came from. I knew that he was of mixed
race and that part of his family came from the Comoros but,
to tell the truth, I didn't know much.

We parted at the Zurich station after exchanging addresses.
He, too, lived in Paris.

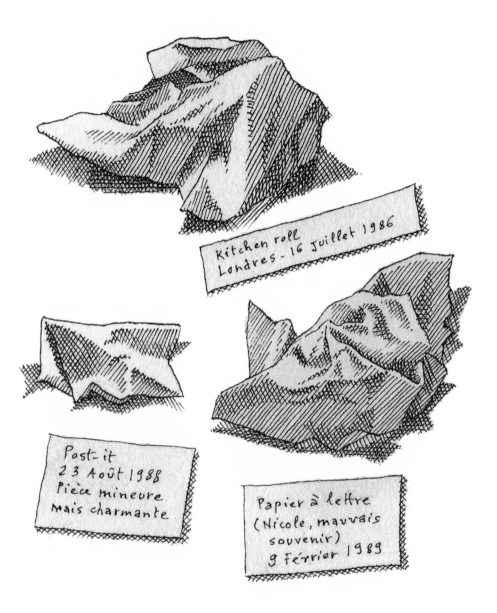

Kitchen roll
Londres - 16 Juillet 1986

Post-it
23 Août 1988
Pièce mineure
mais charmante

Papier à lettre
(Nicole, mauvais
souvenir)
9 Février 1989

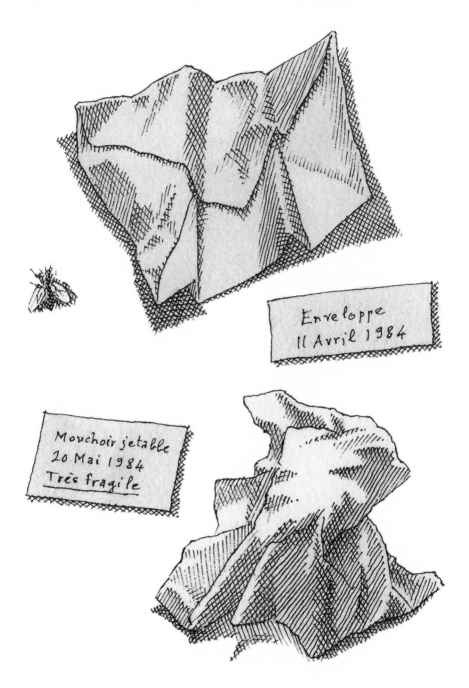

Enveloppe
II Avril 1984

Mouchoir jetable
20 Mai 1984
Très fragile

A few pieces from the Duytveld collection with carefully detailed labels.

We met for our first drink at the bar of the brasserie La Lorraine on the Place des Ternes. A very loud man, visibly drunk, prevented us from having a real conversation. He was, the bartender informed us, Jean Rigaux, an entertainer whose heyday had been in the cabarets of the 1950s. I read Rigaux's memoirs years later, and I don't regret having seen him.

In the weeks that followed, Duytveld invited me to his place. I was intrigued, because I had seen him cautiously gather up a crumpled bill left behind by another customer at La Lorraine.

He lived in the Villa des Ternes, one of those protected spaces sheltering beautiful houses surrounded by gardens in the very heart of Paris. I remembered that Jean Luchaire, a journalist who had worked for the collaborationist press during the Nazi occupation and had been executed afterward, had lived there. Pedro's house was comfortable and quite luxurious, but it wasn't the bourgeois anonymous furnishings that caught your eye; it was the shelving that covered a large expanse of the walls. They were filled with shapes that at first I had trouble making out since the lighting was dim. This is how I discovered that this courteous and self-effacing man methodically collected crumpled pieces of paper.

I never really got an explanation as to the reasons behind this infatuation. "The light and the shadows," he once told me, were what obsessed him. What was written on these papers didn't interest him—besides, many of them were blank,

wrapping papers for example, or disposable handkerchiefs.

Pedro lived alone. Few things besides his collection distracted him. He watched the evening television news broadcast at eight o'clock on the dot. He was very fond of the announcer, Roger Gicquel, who is a little forgotten today. He liked that he had the demeanor of an airline steward, his own profession when he was still a student.

A heart attack brutally felled Pedro. His nephews were delighted to inherit the lovely house in the Villa des Ternes. However, they had the bad idea of flattening all the pieces of paper into a single shoebox big enough to hold them. It was a sad end for this collection, images of which occasionally recur to me still, accompanied by the throaty laughter of the singer Jean Rigaux.

A Rubens drawing and a painting by Eliot Hodgkin.

Eliot Hodgkin

The Hazlitt, Gooden & Fox gallery was located in an elegant little house in the St. James area of London. It sold mainly nineteenth-century paintings, lovely and of good quality, but often a bit dull for my taste.

I went in there one day and discovered a collection of works that I think about to this day. It was an exhibition entitled "Eliot Hodgkin, Painter and Collector." This artist—known to the "happy few"—came from a well-off Quaker family. He was the cousin of Roger Fry, the art historian close to Virginia Woolf and, nearer to our era, he was related to the contemporary painter Howard Hodgkin. All his life he had painted exquisite small-scale works in tempera—a technique that had fallen out of use—depicting fruits, vegetables, and flowers. Collectors from the best of English society snapped up these little gems.

Alongside his career as an artist, Hodgkin put together

Eliot Hodgkin

a collection of rare discernment. Miniaturized works, the largest being a picture by Jean-François de Troy, an eighteenth-century painter. In addition to these pictures, all of great quality, like a Morandi as tiny as it was sumptuous, he brought together a great variety of works on paper that constituted a grouping of exceptional coherence. A powerful sketch by Rubens, a Liotard from the Turkish period, drawings by Ingres, sketches by Degas, some etchings, too, by artists from Wenceslaus Hollar to David Hockney by way of Charles Meryon. Everything had been selected by the same infallible eye and together composed a perfect symphony.

I often look at the small Eliot Hodgkin catalogue, never tiring of it. It's a model for me. So many collections are mere

accumulations created by chance or wealth. At the time of this exhibition, I had dinner with Charles Saatchi, the great contemporary art mogul. I strongly recommended that he go see it. But these little things, as beautiful as they were, were no doubt of little concern to him. There had never been the slightest hint of speculation involving Hodgkin, this modest and serious man whose sense of mischief occasionally flared when he wrote his profession in a hotel guest registry: "Animal tamer."

NOTE

It would be unfair not to mention the memory of Peter Langan in this chapter. A restauranteur in London's Marylebone district, he covered the walls of his establishment, Odin's, with works by his artist friends, the best of the 1970s: David Hockney, Patrick Procktor, Ron Kitaj, and, of course, Eliot Hodgkin. He later opened a grand restaurant near Piccadilly, Langan's Brasserie, where one could encounter Hockney, Francis Bacon, and Lucian Freud. I recall seeing Langan, often dead drunk and lying on the ground. In the end, he didn't get up. His marvelous collection of painter friends, but also of other older Englishmen like Walter Richard Sickert, William Orpen, and William Nicholson, was dispersed, a bit furtively. Eliot Hodgkin was well represented there.

Tangier cocktail: Gin and tonic and Staffordshire porcelain.

Jimmy Stockwell

The Tangerinn, a famous bar in Tangier, was located on a small street near the seaside. This hovel, as I think it could be described, was run by John Sutcliffe, one of the Englishmen who found themselves in Tangier for probably unspeakable reasons. All the denizens of shady Tangier in the postwar period, from the poet Allen Ginsberg to the British socialite David Herbert, son of the Earl of Pembroke, frequented this modest tavern.

That's where I met Jimmy Stockwell. He was slumped under a photograph of the Queen of England that hung askew. He could sense I felt a bit lost and kindly invited me to his table. This sovereign subject, who seemed elderly to me—he must have been the same age as I am now—wore an orange shirt and a large pink scarf. A kind of toupee, the color slightly different from his own hair, was balanced atop his head, and it looked to me like it was powdered.

Some popular English earthenware from

the collection of Jimmy Stockwell.

Jimmy Stockwell at Tangerinn, under a portrait of Queen Elizabeth II.

I was invited to his house the next day for a drink. He lived on rue Goya, in one of those buildings that makes you think of Nice, but more dilapidated. Joe Orton could have lived there.

I was surprised, and I must say amazed, when I entered the interior of what could have been a house in Wiltshire. Stockwell had worked for one of the large auction houses in London before retiring to Tangier. His specialty was ceramics, and he had created a collection of popular English earthenware from Staffordshire and other makers elsewhere. He had accumulated an impressive quantity and had arranged it all around this sophisticated reproduction of an English country

interior. Stockwell insisted on lighting a fire in the small fireplace. It was June.

Khaled, his unceremoniously treated factotum, served us gin and tonics that were refilled as soon as the glasses were empty. The dark-skinned young Moroccan—he must have been from the south—sported a Dalzell tartan kilt.

We inspected many earthenware pieces, dogs, pastoral figures, I can no longer remember. The gin and tonic as well as the heat had taken its toll.

The muezzin's call to prayer suddenly reminded me that we were in Africa. I returned to the old Hotel Cecil, which faced the harshly lit beach. While fighting off mosquitoes, I had a curious dream that took place in Wiltshire, Kent, or Devon. A shepherd was tending his sheep. They were made of ceramic.

Ghislain Mouret in his Parisian apartment on rue de la Planche.

Ghislain Mouret

I t was also in Tangier that I met Ghislain Mouret. I wasn't sure whether this bronzed septuagenarian with straw-colored hair was a businessman or a decorator. He was throwing a party at his imposing house, from which you could make out the lights of Spain. The décor seemed showy, but it was hard to make out much in the semidarkness. In the guise of providing illumination, young Moors—as one said in bygone times—held torches aloft in each of the rooms. Everything was spectacular. The giant dishes of couscous looked like mountains. The assembled crowd evoked a costume film in which the entertainer Jean-Claude Pascal could have starred.

Mouret was one of those characters you encounter once and never see again. Nonetheless, he phoned me one day in Paris. He wanted to show me his apartment on rue de la Planche, the contents of which he was preparing to sell. I had in mind the palatial atmosphere of his Tangier residence, and

so I was curious to pay him a visit. He opened the door for me, dressed in an absinthe-green djellaba. The foyer was covered in purple silk velvet.

After a cocktail served in a heavy vermeil goblet, he showed me around the place. Objects, furniture, and paintings were his passion, he confided in me. The Louis XVI armchairs had been audaciously upholstered in black leather. In the expertly lit glass display cases, I could distinguish *pietra dura* eggs, some antique bronzes, a torso by Berrocal, a sculptor fashionable in the 1970s, all kinds of pretty bibelots of no great distinction. On the wall, some abstract paintings by a certain Kijno, male nudes signed by Claudio Bravo, a glory of Tangier who had irreproachable technique. Everything was impeccable, but it all had the same tenor as elevator music. There was nothing that leapt out; it was all hopelessly insipid.

He showed me photographs of a house he had once owned next to Vaucresson outside Paris, an old sawmill that he had transformed into a sort of modern-day château. One would have seen similar designs featured at the time in all the interior decoration magazines.

Decoration as such and collecting rarely go hand in hand. So many places where everything is arranged with "taste" would not withstand inspection by a severe eye. I reacted ecstatically; he no doubt believed me. The sale of his possessions was a success. The catalogue, lavishly illustrated, praised Mouret's refinement. Photographs showed him accompanied

by Elizabeth Chavchavadzé, Fred de Cabrol, and Valerian Rybar, the interior design "stars" of a certain era.

I think of him sometimes. In particular, I remember him at one of those costume soirées that could have taken place only in Tangier. The theme was "Ancient Rome." Mouret proudly sported a leather breastplate that was the same hue as his sun-saturated face.

Jacques Bixio, nicknamed the doll doctor, examining a patient.

Jacques Bixio

It was while doing a feature in drawings for *Harper's Bazaar* that I met Jacques Bixio. This was one of my first commissions. I must have been twenty years old. The magazine's Paris correspondent was one of his close friends. "He's the consummate doll specialist," she told me emphatically. "He is a great Parisian figure."

We went to his house, an eccentric duplex apartment, close to Bonne-Nouvelle, near the center of Paris, just east of the Opera. He greeted us with enthusiasm, dressed in a shirt with billowing sleeves. Bixio was an old-time homosexual, an ageless man with dyed hair. Beneath his long lashes, his insistent gaze irritated me. Probably a friend of Jacques Chazot, the flamboyant dancer and actor who played the role of the snobbish socialite.

Dolls had invaded all the rooms, a bit like cockroaches. I've always felt somewhat ill at ease facing those porcelain lasses with their immobile eyes.

Some dolls from the collection of Jacques Bixio.

He showed us his entire collection, explaining the differences, listing the names of various manufacturers one by one: Baby Bru, Baby Schmitt, P. J. Gallais & Co., Twin Baby, Baby Steiner, Bayeux & Mothereau . . .

I focused on a page in my notebook. Lunchtime was approaching. Bixio invited us to share his meal. I pretended to have another appointment, feeling suddenly very oppressed.

In the end I was quite satisfied (a rather big word) with my drawings. Dolls are an easy subject to draw. They don't move, they're soulless. Simple objects.

As the years went by, I moved into an apartment not far from Bixio's. I passed him one day and, out of timidity, I didn't greet him, thinking that he would not remember the young fellow he had once received. He never forgave me for that. I know this from several of his friends who told me of his bitter remarks about me. Bixio has since passed on to the heaven (more likely the hell) of dolls. Did he take his rancor toward me along with him? And his dolls, have they found a new guardian?

Alain W.

I saw Alain W. for the first time at one of those parties in the Les Halles district of Paris. They had demolished the beautiful pavilions designed for the city's central market in the nineteenth century by architect Victor Baltard, replacing them with a gigantic hole. The Centre Pompidou was under construction. A species that nowadays we'd call "trendy" lived and found diversions in these environs.

Alain W. already had his characteristic imposing belly, displayed under a T-shirt emblazoned with a print by the Japanese woodblock master Utagawa Kuniyoshi. I was always bored by this type of gathering. But this bearded fellow with round glasses seemed different to me, and so we got to know each other.

He invited me to his home, a studio on a tree-lined passageway near the Champs-Élysées frequented by few people. He lived in a contrived disarray that smelled a bit like feline

urine—cats did indeed share his home. From my first visit, I was seduced by the accumulation of books, old records, trinkets, and paintings. A collector's interior where each object had been chosen for a specific reason. Another collection filled the kitchen: countless empty bottles, my host being not indifferent to the virtues of drink.

He had worked with François Mathey, an eccentric curator of the sort that no longer exists—they've all been replaced by cultural apparatchiks—who organized the most original exhibitions at the Musée des Arts Décoratifs (a place today emptied of its treasures, where one no longer sees anything but commercial presentations). Mathey had passed along his hankering for rarity to Alain, who had become a great poster specialist.

He later moved to another atelier, near Place Pereire, where he installed his dust-covered objects from the previous abode. I often found him at Pétrissans, an old cellar restaurant on Avenue Niel, a vestige of a bygone era that, thankfully, remains in business.

He eventually found an old garage in the 18th arrondissement that he transformed into an immense room where a stuffed giraffe towered over the objects. Paintings by Pierre Bettencourt, a drawing by Aloys Zötl, an assemblage box by Yolande Fièvre, projects by the Art Deco poster artist Cassandre (on whom he was the expert), African artifacts, and multiple other things, all covered in the same dust, carefully preserved over the years.

Alain W.

He was interested in African statues depicting settlers, little sought after, and thus inexpensive (a shrewd collector always buys outside of trends). He had accumulated a significant quantity and, I believe, was preparing an exhibition on the subject.

Filippo G.

During a stay in Rome, Umberto took me to the home of Filippo G., one of his old collector friends. A former curator for several museums, he had amassed very beautiful pieces that filled his apartment in one of the buildings in the Mussolini district that I admired since they irresistibly evoked the finest paintings of Giorgio de Chirico.

Filippo, a tall, rather slender fellow, welcomed us with a warmth you don't find in Paris. His ground floor was filled with all the things that interested us, Umberto and me: Greek and Roman marbles, Islamic ceramics, Renaissance bronzes, and most of all a tiny panel by Sebastiano del Piombo, probably a fragment. There were also many wax sculptures, that peculiar material that always gives me the false impression of being on the verge of melting. Wax was in fact his specialty, and he showed us each piece in his remarkable collection.

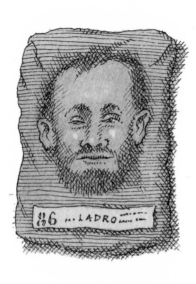

86 ... LADRO ...

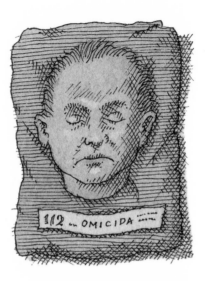

112 ... OMICIDA ...

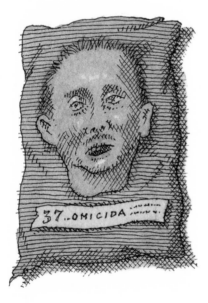

37 ... OMICIDA ...

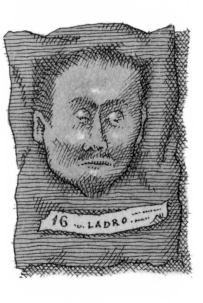

16 ... LADRO ...

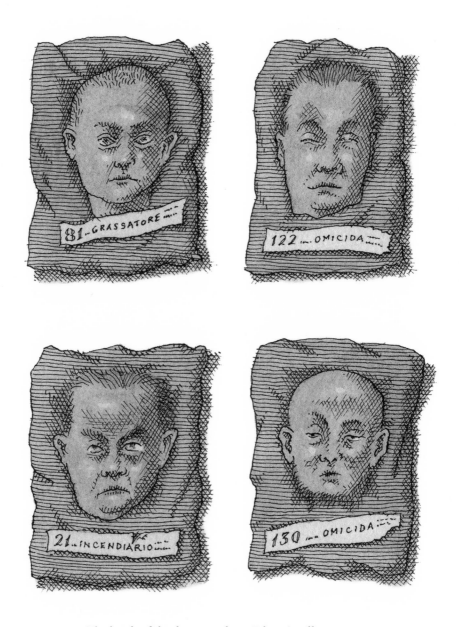

The heads of dead criminals in Filippo's cellar.

I got the feeling that Umberto was uneasy, as if he wanted to ask his friend a question, but whenever he was about to do so, he was unable. Finally he took the plunge and whispered: "You'll show us the cellar..." I didn't really understand and sensed a brief intimation of disquiet. But Filippo didn't seem at all bothered and guided us to the back of the apartment. A padded door opened onto a staircase leading indeed to a sort of cellar, a dark but still comfortable room. We were invited to sit down on the lone piece of furniture, a sofa covered in a charcoal-colored flannel. Opening a small refrigerator built into the wall, our friend uncorked a bottle of that wine from Asti called *spumante*.

The wall facing us suddenly lit up, revealing racks upon which human heads were arranged. They were wax models of dead criminals with grafts of their own hair. They were strikingly realistic. Filippo sat next to us, staring at these poor wretches. Death had not wiped the viciousness from their faces. These works had been created in the nineteenth century and came from I don't know what institution. Their acquisition must have been the culmination of a clandestine transaction.

Umberto, with a gesture of the elbow, signaled that we should depart.

Filippo didn't move. We left him on the sofa. I learned that he sat there every evening, as others might watch a football

match on television. We had plans to join friends at Augustea, a restaurant close to the banks of the Tiber. Those empty-eyed murderers continued to haunt me. I didn't have much of an appetite that evening.

Glass menagerie

Pierre R.

Which habitué of the art and antiques auction house Hôtel Drouot hasn't crossed paths with Pierre R., the man in the red scarf? Looking like a professor from another era, dressed unfailingly in three-piece suits that are seldom worn these days, he's the incarnation of one of the characters in the autobiography of illustrator and collector Philippe Jullian, *La Brocante*, a book dealing with a love of small objects.

This academician, former director of one of the great museums in the world, specialist in seventeenth-century painting, had long intrigued me because he collected minor artists, often unknown, who seemed to excite him more than the great masters. I knew that he had acquired, among others, pastels by Simon Bussy and canvases by Toshio Bando, the Paris-dwelling friend of Foujita. These two painters had interested me for forty years, and a number of their works had passed through my hands.

Pierre R.

One day my friend Nicolas S. took me to his house. He lived in the 6th arrondissement, almost directly across from the beautiful hotel where F. Scott Fitzgerald had stayed.

At the end of a narrow, tree-filled courtyard was his house, a labyrinth made up of a succession of small rooms on two floors, each filled from floor to ceiling with paintings, drawings, and books. It was the collection of an inquisitive man always on the lookout, in which Philippe de Champaigne was adjacent to Marguerite Burnat-Provins, André Devambez, and a number of artists scorned by "important" collectors who thus ignore an entire swath of art. Oddly enough, these works by marginal artists sometimes shine with such singular brilliance

that they eclipse those of the greats. Seen and reviewed so frequently in books, museums, and exhibitions, the latter end up losing all freshness and and often sink into tedium.

Nicolas had also told me about the Murano glassware accumulated by Pierre R. In a small room I discovered hundreds, perhaps more, of these delicate objects that you see in shops in Venice. They filled entire shelves. Delightful or kitsch, this multitude of small subjects shimmered like cartoon pirate booty, the intensely luminous colors achievable only with translucent materials.

Years ago I was interested in these delicate bibelots from a rather earlier period. The paterfamilias I became was ultimately dissuaded from collecting them, even though my four children have, truth be told, never broken anything—or almost nothing. But this reasoning proved to have been mistaken and I realized that these glass marvels have managed to pass through the centuries intact.

I tried in vain to acquire this Chinese Mogul-style jade cup from Rolande-Louise de Petitpierre. She assured me that it had once belonged to William Beckford, who'd had the gilded mounting made. Another time, she told me—after swearing me to secrecy—that she was a direct descendant of Horace Walpole. The things people say . . .

Rolande-Louise de Petitpierre

For a while, I would often pass by an elegant freckled woman wearing old-fashioned makeup at the auction house. You could detect a beauty in her face that had gradually dissipated. She had something of Gloria Swanson from *Sunset Boulevard* about her, a fixity in her gaze.

One day, while we were both looking at an object at the same time in one of those sordid rooms on rue Drouot, she told me that my father would have "adored" it—I no longer remember what it was. I don't think she knew who I was or who my father was. It didn't matter, but that is how I met Rolande-Louise de Petitpierre. She gave me her phone number and, intrigued, I ended up calling her.

I was summoned, because she was the one who determined the precise moment we could see each other. In fact, she had a shop near the quays of the Seine, opposite Notre Dame, where she received people when it suited her. After

knocking on a rolling iron shutter that was three-quarters lowered, I heard a sonorous voice, like that of the actress and grande dame Edwige Feuillère, asking me to come back a bit later. I finally ducked into her lair, practically crawling on all fours. She ordered me to stay put in an area of about two square meters, the only space where one could stand amidst piles of furniture and bibelots all chosen with delicate taste. Painted-wood armchairs or commodes from the eighteenth century, ornamental drawings, figures in spun glass in small vitrines . . . The entire jumble delighted me, but I realized very quickly that it was impossible, or very difficult in any case, to buy whatever it might be, since Rolande-Louise was above all a collector and not much of a merchant.

I returned to her place several times. Always the same ritual. I was there at the appointed time but had to wait. She was probably just finishing getting dressed—the lashes that encircled her pale eyes were always overloaded with kohl, and this preparation must have taken considerable time.

A lightbulb hanging from the ceiling dimly illuminated the treasures I coveted but could never acquire. She was from a good bourgeois family in eastern France, a region as exotic and inaccessible to me as New Guinea, and she must have been pretty, but had remained unmarried. With a risqué gleam in her eye, she once mentioned Gaston Palewski, the close associate who had accompanied General de Gaulle to London and was later torn between politics and duchesses.

Rolande-Louise de Petitpierre

Had she loved him, hopelessly, while he had an affair with the spirited Nancy Mitford? "A charming man," she murmured in a trembling voice.

Eventually she no longer answered the phone. She was no longer seen at the Hôtel Drouot. What became of the possessions that so resembled her? I envision again this curious store that wasn't a store, because you couldn't buy anything. A cast-iron spiral staircase led to the floor where she must have lived—though I was never invited there—in an atmosphere of Tennessee Williams transposed to Paris. Alexandra del Lago, the faded movie star in *Sweet Bird of Youth* . . . Rolande-Louise, I often think of you, of that exquisite bric-a-brac. In the end it wasn't much different from what was amassed by Palewski where he lived on rue Bonaparte. Italian furniture, old pictures, elegant bibelots . . . In an enfilade of rooms, the general's former chief of staff had reconstituted a sort of Roman aristocratic apartment that could not have left the old Lorraine beauty indifferent, since she was undoubtedly more attracted to objects than men.

my collection

The collection that I know best and that is the most difficult for me to talk about is obviously my own. It's elusive. I have owned, I confess, thousands of objects. Even if today most of them are nothing more than memories, I continue to seek, to find, to acquire. Acquisition being, for some mysterious reason, the most important act, like a gambler throwing dice. The idea of speculation has never crossed my mind, nor of "decoration." Collecting is for me both essential and completely useless.

I can't recall what the first thing was that I considered a collector's item. All I can say is that at the age when children love toys, toys interested me only if I found in them a certain beauty. So I can still see the gift presented to me when I, rather late, finally became toilet-trained: a sort of little carriage drawn by a white horse. What I found appealing was its beautiful black lacquer. I had no desire to play with what

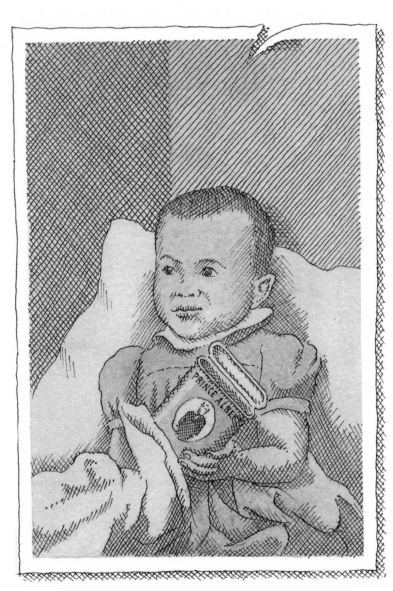

1951. The first object in my collection, a Prince Albert tobacco box that I would be happy to find again.

had already become a piece of my collection, a thing I wanted simply to contemplate.

Very early on, when I was around seven or eight years old, my father would take me to antique shops and even to the flea market. I can still hear the Asian art dealer talking to him: "Tell him to choose a print." He had the same intonation as actors from the time of black-and-white films. I was in heaven. I could list all the shop names that would mean nothing to anyone because they all closed long ago.

My father used to give me secondhand objects: a slightly chipped East India Company cup, a fragment of a Chinese painting, an old volume of the *Manga*, the encyclopedia of sketches by Hokusai, whom I still consider to be the greatest Japanese artist and some of whose drawings I own today.

In the bedroom that I shared with my brother, I set up a miniature museum where each object was accompanied by a carefully handwritten label. Visitors—from Prince Buu Loc, an old friend of my father, to radiator repairmen—were allowed to write their impressions in a guest book.

Around eleven years of age, I became interested in weapons and armor from Japan. This infatuation stemmed from an old book of my father's that listed extensive details about sabers, breastplates, and helmets. I tried to copy it. From then on, I began compiling a collection whose crowning element was a complete set of armor acquired when I was about fourteen years old.

This incessant desire to accumulate abated a bit at the age when all of a sudden you start thinking of going out at night, preferably accompanied. A few objects then disappeared in order to subsidize other needs. But this was merely an interlude.

My tastes changed as well. Many long stays in London opened up new horizons for me. Through reading Virginia Woolf and other members of what was called the Bloomsbury group, I discovered the painters, Virginia's sister Vanessa Bell, Duncan Grant, and Simon Bussy, an exquisite French artist friend of Matisse married to the sister of Lytton Strachey, an important writer in the group. This then led to learning about other aspects of English painting from this period.

It was also around the time that I encountered the irresistible attractions of Parisian auction house salesrooms. I vaguely recall that the old Hôtel Drouot was under reconstruction. The auctioneers had taken over the former Gare d'Orsay before it became a museum. I realized that, every day, copious amounts of ceaselessly replenished merchandise were put on offer to covetous amateurs and professionals. Later reinstalled on rue Drouot, near where I lived at the time, this place of perdition became for me the equivalent of a casino for a gambler. Along with those in the auction houses in London and New York, the temptations were constant.

Toward the end of the 1970s, Christian Bérard, a remarkable figure of the interwar years, began to fascinate me. I

This self-portrait by Toshio Bando was my favorite painting for a long time. Spotted in 1976 on rue Bonaparte, the painting had a price that prevented me from buying it. I later saw its owner again at a New York party—where I recall Andy Warhol was present—and he informed me that the price had dropped by half. Upon my return I rushed to pick up this twentieth-century Japanese Bronzino. One day I had to part with it. Sic transit gloria mundi . . .

don't know how it started, perhaps I discovered an image in a book or a magazine. He was, and is still, known for the wrong reasons; he was referred to as a stage designer, a fashion illustrator (in fact, that was simply his livelihood), an arbiter of elegance—he who looked like a vagrant. "All women dress only for him," it was said. But he was above all an exceptional painter, sometimes an equal of the greatest. Francis Bacon, when we met, expressed his own interest in him, and some of Bacon's paintings are reminiscent of early works by the figure nicknamed Bébé. Lucian Freud, today considered to be a giant, did a portrait—probably his finest drawing—of his French friend. As for Balthus, he insisted on going to a Left Bank gallery for the opening of an exhibition of spellbinding portraits by Bérard. That was the same evening as the inauguration of Balthus's great retrospective at the Centre Pompidou. This bearded figure, whose paintings no one or almost no one knows, mattered to these three great artists.

I became interested at the same time in other "neo-romantics," as they were anointed by the critic Waldemar George; aside from Bérard, the main ones were the brothers Eugène and Leonid Berman, as well as Pavel Tchelitchew, all three of Russian origin. Correspondingly, photographers like Cecil Beaton, Hoyningen-Huene, and George Platt Lynes, others as well, shared the same aesthetic, both melancholy and unreal. I then assembled what I will pretentiously call an important collection of this entire movement. Having put together a

The catalogue cover from my sale in London.

very complete set, I decided to rid myself of it, consigning it all to a large English auction house. The simple catalogue, abundantly illustrated and annotated, favorably replaced the cumbersome ownership of these objects.

Since then, following a divorce that ended up relieving me of a large portion of what might have remained mine, I have continued to practice the only sport that suits me. Almost everything attracts me, from archaeology to Islam to Asia and drawings from all eras. Japan, which was so important when I was a child, has regained significance. The books have never stopped accumulating, but I don't think of them as a collection. For me, they're simply a reservoir of indispensable knowledge that a computer could never replace.

Time has passed. I occasionally experience a certain satisfaction in thinking about the things I loved even before the multitudes that have since become infatuated with them. I sold everything before it took on a value I could not have imagined. This is the lot of a poor collector who sells only to buy again. Drawings by Jacopo Ligozzi, Guercino, Carmontelle, Alberto Giacometti, Domenico Gnoli, Balthus, Lucian Freud, Andy Warhol, Rex Whistler; sculptures from the Renaissance or by Calder; furniture and objects by Jean-Michel Frank, Line Vautrin, Jean Prouvé, all of these have passed through my hands. I miss nothing, especially not the profit I could have drawn. These old possessions are now nothing but extraneous commodities, and I find that they've become almost vulgar.

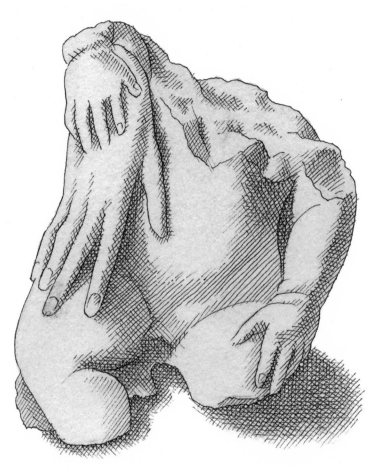

Having bought some objects from the apartment that was no longer mine, Nicolas S. was considerate enough to offer me a beautiful fifteenth-century Italian marble fragment that had once belonged to me. I am naive enough to think that this beautiful stone baby's belly was happy to be returned to its old owner.

Head of Holofernes in marble, Italy, sixteenth century,
and a troll from the collection of my daughter Cléo.

Vulgar, yes, like most new "collectors" of obscene wealth. In earlier times, the powerful were rewarded with titles of nobility that gave them glory and prestige. Nowadays, art and "patronage" have replaced these honors. A kind of halo now crowns dull, laborious men who have lived only for money and power. With art they acquire the so-called "glamour" they so lacked, while also realizing that it's a considerable source of profit. Nonetheless, the delight an aesthete can derive from looking at artworks remains forever alien to them.

What becomes of collections? The largest, the most valuable, often the least significant, end up in museums or become

the property of foundations. They are testament to one man's fortune, vanity or, at best, to an eye, a taste, an era. Some are exemplary, like that of Armenian oil magnate Calouste Gulbenkian in Lisbon—eclecticism and perfection. For my part, a mix of disenchantment and wisdom acquired with age has taught me that nothing belongs to us. The poor sovereigns who had themselves interred with their treasures have all been pillaged. For a long time to come, for my own amusement, I will continue giving in to the temptations of discovery and acquisition. New domains continue to intrigue me, or at least I hope they will. I know, however, that I can part company with it all.

I hope to leave behind only those little things, probably in a sorry state, but so precious, that were made or given to me by my children in the past: a figurine in modeling clay, a cutout, a broken seashell. Rosebud . . .

My son Edward's terra cotta eggplant.

Gilles D. spotted this carved wooden sea horse in a secondhand shop in Richmond, a chic suburb of London. Rudolf Nureyev, with whom he was staying, presented it to him. Though acquainted with this kind of object, I learned later from Gilles that it was a mold intended for the fabrication of papier-mâché works.

Gilles D.

My friend Gilles D., a collector without appearing to be one, doesn't figure among those erudite specialists who knows exactly what they're buying. He opens an art book only to look at the pictures and chooses his purchases solely on the strength of his infallible eye.

I remember the first time I saw him. I was a very young man. I had to do some drawings on rue de l'Université, at the house of Karl Lagerfeld, then still a little-known designer who successfully ran a brand called Chloé. It was the same reporting assignment for *Harper's Bazaar* for which I had already sketched Jacques Bixio's dolls.

The apartment was undergoing renovation. It was being transformed from a "high design" style to that of the 1930s. Furniture by Ruhlmann or Printz, lacquer pieces by Jean Dunand, had supplanted brushed aluminum chairs by Martine

A photo of Gilles in his youth.

Dufour. The future Chanel guru of rue Cambon was fond of these changes in scenery.

I was surprised to see that Andy Warhol was there making a film, *L'Amour*, with two young American actresses and models, Jane Forth and Donna Jordan—what has become of them? The atmosphere was fun but I didn't really feel comfortable. I was very intimidated by these trendy creatures; the museum rat I had been up until then was completely clueless about them. Lagerfeld's mother lived in one part of the apartment and kindly offered Coca-Cola to this little crowd.

A young man with a faun-like physique appeared. It was Gilles. He was carrying a large bag, and from it he took out

some Saint Laurent shirts, probably provided by the couturier, that he cheerfully distributed. He seemed very much at ease in this apartment.

Only later did we become friends. Even later still he benevolently took care of my teenage daughter Olympia, whom he hired as an intern when he directed the Chanel studio.

He was indulgently fond of everything that I had in my home, and since I often ran out of money, I sold him paintings and objects. His apartment was very different from mine, even more jampacked, if that's possible. It was very much in his own image: tufted armchairs, flowers, candles, photographs of boys, but also paintings from the nineteenth and twentieth centuries, all chosen with his eagle eye (rather restrained, by the way). I've rarely encountered anyone who had so little bookish knowledge but who could so immediately recognize beauty.

I have often sat on the deep damask sofa made by Decour, the exorbitantly priced Paris upholsterer to the rich (which Gilles is not, thank God). He told me old stories about his stays with the dancer Rudolf Nureyev, cruising with actor Helmut Berger, the Proust ball thrown by the Rothschilds at Château de Ferrières, the Oriental ball given by Baron de Redé at the Hôtel Lambert, and other parties. A vanished world . . . He also told me about every item in the small collection he never stopped rearranging, always trying to find just the right spot for each thing. He excelled at this fastidious art of juxtaposition.

Eggs by Tchelitchew and a Japanese head.

I have owned many, many objects. I sometimes regret not having kept traces of all this. I've parted with it all, missing nothing, actually. Even less when I see them again in an apartment like Gilles's. All the drawings, the paintings by Christian Bérard, Eugène and Leonid Berman, Pavel Tchelitchew, Simon Bussy, Duncan Grant have found their homes. I look at them when I go to his place. They're still somewhat mine, but they're primarily Gilles's, who would never part ways with them. There's something reassuring about that, as if I had left my children with someone whom I trust.

Boris Kochno

"If catastrophe ever befell Paris as it did Pompeii, and a few centuries later an archaeologist was alerted to discover the intact home of Boris Kochno, I believe that one could reconstruct the art history of the first half of the twentieth century based on this place."

I wrote this sentence in a book more than twenty years ago, and I haven't changed my mind about the collection of this dear friend, whom I met in 1983, and who was my living link to an era I didn't personally experience that fascinated me.

This Russian emigrant, who became secretary to Diaghilev as a teenager, had been not only a friend to all those artists, from Picasso to Balthus, but also the companion of my favorite painter, Christian Bérard, until his death in 1949. I remember my first visit to his place. The dilapidated façade of the house resembled one of the ballet stage sets that punctuated his

career. It was a former depot for those carts that strongmen at Les Halles marketplace used to transport goods. In fact, he lived very close to rue Montorgueil, just steps away from what was then called the belly of Paris.

The front door opened directly onto a long room, the only one that I entered while he was alive. I was very impressed when I met this vigorous bald man with his countenance marked by a black moustache. By then, he was having great difficulty moving around. Everything in this haunt, where daylight barely penetrated, evoked the life of a legendary figure. An orderly jumble that brought together traces of a long and rich career, but also objects he had acquired, chosen with the eye of a great connoisseur. Dust and decay did nothing to diminish the luster of these treasures. Each thing had a history: the sumptuous portrait of Bérard by Lucian Freud—which could have been the work of a modern Dürer—a superb drawing of Gala by Dalí (though Dalí is an artist I don't particularly respond to), a bust of Laocoön that he attributed to Pierre Puget, a touching "box of cigarette butts" cobbled together by Picasso for his friend during the Occupation—which I was able to obtain for myself later—and innumerable other works or trinkets (a bit feeble, that term) that formed a sort of inseparable family. This mixture of souvenirs, paintings, drawings by artists he had known, rarities of all periods, was a revelation to me. I believe that he, along with my father, was one of my strongest influences.

*Boris putting his head through a canvas painted by Bérard for a ball
(based on a photo by François Halard).*

A box of cigarette butts Picasso gave Kochno.

My understanding of an era that was not mine but his, as well as my familiarity with obscure figures he had known, astonished him and brought us closer. I visited him until his last days and accompanied him to the Père Lachaise Cemetery where a place for him was found near the grave of his lover, Bébé.

The coherence, the strength of what he had accumulated became even more evident in 1991, when the contents of the little house in rue Marie-Stuart were dispersed at auction in Monte Carlo. There I found what I had already known, but also documents, manuscripts, photographs carefully classified and preserved by Boris that I had never seen: texts by Serge

Diaghilev, impassioned letters from Cole Porter to Kochno, the romantic correspondence between Igor Stravinsky and his future wife when both were still married to others, a defense of ballet by Louis-Ferdinand Céline, curious erotic drawings by a Russian artist whose name escapes me, invaluable testaments, many of which, fortunately, were purchased by institutions. Umberto Pasti was there, too, but we barely knew each other at the time. The memory of those two days spent in Monaco has not left me. Happy days...

I am writing these lines while looking at a fragment of a Roman bust lying upon my desk, as it did on Boris's. I purchased it from an antiquarian a few years after the auction. Its odyssey, which began over two thousand years ago, continues.

Detail of one of the panels created by Bérard for the home of Marie-Blanche de Polignac. The model for the figure on the left was Alberto Giacometti.

Jacques P.

An American friend asked me one day if I could do a series of drawings for one of his clients, drawings about Jean Hugo, the great grandson of the poet and playwright, a delicate and unclassifiable artist of whom I'm particularly fond. In the 1930s, he painted often tiny gouaches that look naive but actually are not at all. "You paint for kings," Paul Morand told him. I had to draw his portrait, his friends, his house—in a word, his universe. I didn't know the mysterious commissioner, but I executed the work with pleasure.

I must not have met Jacques P. until later. He was what is called a "nose" for one of the largest perfume houses, if not the largest. A slender man with fine features, a rather bald head, reserved and very polite. His father, a pharmacist in Provence, and his mother had introduced him to arts and letters when he was a young child because they were very close to Albert Camus, René Char, and Nicolas de Staël. This is how Jacques

knew Pierre-André Benoit, the art publisher of the region who produced small print runs of books written by poets like Char and illustrated by Miró, Braque, or Hugo. This is where his passion for the latter originated, and he owned a large number of Hugo's works.

Aside from the pieces by Jean Hugo, his apartment near the Champ-de-Mars was filled with paintings by Josef Šima, Geneviève Asse, John Bishop, and Joan Mitchell, whose large canvas dominated the living room. A true selection, refined and personal.

Through Hugo, who was very close with Jean Cocteau and Christian Bérard, he started to take an interest in all the neo-romantic artists who formed the basis of my collection. He would come to my house and inspect everything. In his very slight southern French accent, he would say to me, "Let me know when you'd like to sell such and such a painting..." And inevitably, when I needed to pay bills or debts, or buy a new object, we made a deal.

Jacques's collection took on a new dimension. Alongside subtle abstract paintings, I saw works appear that for a long time had been on my own walls. An impressive library—not a bibliophile's, but that of a devotee and a reader—completed the ensemble.

Afterward he commissioned some furniture from me, since I happen to make it. He also solicited my help in selecting colors for seating or some curtains. All this contributed to

Jacques P.

an odd feeling whenever I went to his place. So many things had belonged to me, along with the furniture I had designed.

In his living room a mysterious and magnificent canvas drew your attention right away: a large beach scene by Bérard, in which he had portrayed himself stranded on the shore. It was one of the artist's four most important works, all on the same subject. One, having belonged to the great collector James Soby, is now in the Museum of Modern Art in New York. A second, which had long hung in the legendary Paris salon of Marie-Laure de Noailles, has stayed in the family. A third was located in the London home of the wealthy aesthete Peter Watson, owner of the magazine *Horizon* edited by Cyril

Connolly. A fire reduced that house and its contents to ashes. Jacques's beach had belonged to Edward James, patron of Salvador Dalí when he was still a painter and other artists like the Belgian René Magritte. It was part of the collection accumulated in the extraordinary surrealist pavilion James had created at his property West Dean in southeast England.

I remember the days preceding the sale of the contents of West Dean in 1986. I became so obsessed with the painting I could no longer sleep. I was astonished when I emerged as the winning bidder. This kind of acquisition elicits the thrill of bungee jumping—something I haven't yet tried to do. Having made the purchase sufficed. I am happy to see it now on my friend Jacques's wall, safe and in good company.

Howard L.

New Yorkers these days tend to spend less time on the Upper East Side, the neighborhood that runs along Central Park and extends to the top of Manhattan. Those "in the know" spend time only downtown, at the bottom of the island. That's where, so they say, everything happens.

For my part, I continue to love the old bourgeois uptown areas, with their tranquil streets lined with reassuring houses, where nothing seems to have changed since my youth. The same old women powdered and stylishly dressed, or perhaps their descendants, still walking their white poodles, and some of the old businesses that, miraculously, remain.

I found myself one summer in one of these establishments on Lexington Avenue: Donohue's, a steakhouse as old as its regular customers. I was leafing through an auction catalogue waiting for a dish that never arrived. My neighbor struck up a conversation, joking about the fact that together he and I

slightly lowered the average age of the clientele. He, too, frequented auction house salesrooms, and we realized that we had similar tastes.

As I left the restaurant with him, I noticed that this small dark man was oddly dressed in a brightly colored African boubou that seemed well suited to the stifling heat of New York. We walked alongside each other and he amiably asked if I'd like to stop by his house. I was surprised, upon entering his foyer, by the zebra skin on the floor, and the two heads affixed to the walls, one a rhinoceros, the other a hippopotamus. His father, he explained, had been a Romanian emigrant who had done business in Africa and even ended up fluent in several local dialects. These trophies, like his attire, were family keepsakes.

Howard L., that was his name, was in the real estate business and no longer had anything to do with Africa. He showed me around the rest of the apartment. Ancient scientific instruments, models of staircases and rooftops; a sumptuous terra cotta sculpture by Clodion stood alongside the most beautiful collection of old drawings I'd ever seen.

How surprised I was to discover a small portrait in gray ink from the early nineteenth century. Round in size and of rare perfection, it portrayed a young girl with very short hair pinning a butterfly onto a map of the world. This drawing, done by a certain Madame Greider, had belonged to me. I recalled a handwritten letter, contemporary with the work,

The drawing by Madame Greider that Ingres admired.

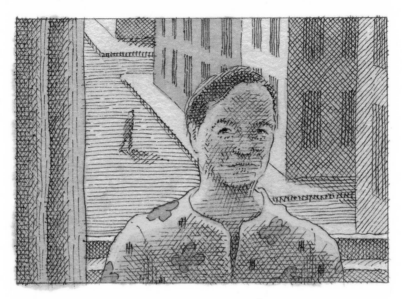

Howard L. in New York.

that accompanied it. It reported that the painter Ingres, who had seen it, appreciated its exceptional quality of execution. Such coincidences seal friendships between collectors.

Ever since then I have seen Howard regularly, along with his wife, Sally, as blond as he is dark, whenever they are in Paris. They were kind enough to acquire some of my drawings, which I am proud to see alongside masterpieces. We always dine on Place de l'Odéon, at La Restaurant Méditerranée, appropriately once owned by another collector, Jean Subrenat, who generously welcomed artists just after the war. Boris Kochno and Christian Bérard came as neighbors, as did Picasso, Jean Cocteau, and Tom Keogh, who is largely

forgotten today. Balthus, whose workshop was in the nearby Cour de Rohan, created a magnificent sign, *Le Chat de la Méditerranée*, for this spot, a sketch of which I used to own. For a time, I also had a drawing by Lucian Freud, again originating in Subrenat's collection, that was a preparatory study for his masterly portrait of Bérard.

In thinking about this fish restaurant and the collector that I am, I tell myself that in the end I am just like those fishermen who throw their catch back into the water after waiting for hours to reel it in.

Ermolaï von Trovaso
Trieste, 1906–Tampa, 1998
Collector

Epilogue

Dr. Barnes, Henri d'Allemagne, Charles Gillot, Baron de Hirsch, Frits Lugt, Count Panza di Biumo, François Pinault, Roberto Castro Polo, Lieutenant-General Pitt Rivers, Ermolaï von Trovaso, Sir Richard Wallace . . .

I will surely be reproached for not having mentioned them or many others, but I was content to recognize only a few, rather unknown collectors in the still-accessible compartments of my memory. Some of them have left us, and what they amassed has been largely dispersed. This modest volume will at least leave a trace of what was once one of their reasons to live.

Index

Acknowledgements

I would like to thank Carlos d'Arenberg, Andrea Daninos, Gilles Dufour, François Halard, Peter Hinwood, Stephan Janson, Howard Lepow, Franck Maubert, Edouard Merino, Patrick Modiano, Umberto Pasti, Emmanuel Pierre, Jacques Polge, Pierre Rosenberg, and Alain Weill.

I am equally grateful to Alice d'Andigné, Teresa Cremisi, and Nicolas Schwed for their help and their patience.

newvesselpress.com